PENGUIN BOOKS

GREAT HOUSEWIVES OF ART

Sally Swain was born in 1958 in Sydney, Australia. Self-taught, with no art school training, she devised the series "Great Housewives of Art" for an exhibition in Australia in 1987 with the intent of exploring, through parody, the notion of "the great woman behind the great man." Appropriating the recognizable style of great paintings, she has reinterpreted their contents in a provocative and witty manner, connecting "high art" with aspects of women's experiences in the home. Sally Swain believes that neither great art nor feminism should be taken *too* seriously, but would be thrilled if her "Great Housewives" induced smiles—and even more thrilled if they provoked questions about the nature of art and women's roles.

Penguin Books

GREAT HOUSEWIVES OF ART

SALLY SWAIN

PENGUIN BOOKS
Published by the Penguin Group
Viking Penguin Inc., 40 West 23rd Street,
New York, New York 10010, U.S.A.
Penguin Books Ltd, 27 Wrights Lane,
London W8 5TZ, England
Penguin Books Australia Ltd, Ringwood,
Victoria, Australia
Penguin Books Canada Ltd, 2801 John Street,
Markham, Ontario, Canada L3R 1B4
Penguin Books (N.Z.) Ltd, 182–190 Wairau Road,
Auckland 10, New Zealand

Penguin Books Ltd, Registered Offices:
Harmondsworth, Middlesex, England

First published in Canada by Doubleday Canada Limited and
in Great Britain by Grafton Books 1988
Published in Penguin Books 1989

10 9 8 7 6 5 4 3 2 1

LIBRARY OF CONGRESS CATALOGING IN PUBLICATION DATA
Swain, Sally.
Great housewives of art / Sally Swain.
p. cm.
ISBN 0 14 01.1586 2 (pbk.)
1. Artists' wives—Caricatures and cartoons. 2. American wit and humor, pictorial. I. Title.
NC1429.S84A4 1989
741.5'973—dc 19 88-31327

Printed in Japan
Set in ITC Garamond
Designed by Beth Tondreau Design/Gabrielle Hamberg

For
Iris, David, Jennie
and Riju

A Letter
to the World of Art

This morning, in between baking the potted plants and ironing the kids, strange thoughts popped into my head.

My husband, Art Extraordinaire, is a great painter, right? I spend all my time tied to the house, toiling away for him and the kids. Well, without me, he wouldn't be free to *be* Mr. Art Extraordinaire. So, why doesn't he give me a little recognition and paint what I do around the house as wife, mother, and homemaker? . . .

Soon after, while reheating yesterday's cupboard, I thought: how silly of me! My day is full of boring, trivial, repetitive, mindless, and often pointless tasks. Who wants to look at pictures of those? After vacuuming the vegetables, I settled down to a good long, five-minute tea-break. Further questions troubled my previously disinfected and waterlogged brain.

Why don't women win medals for the cleanest, best-kept bathroom, or book prizes for outstanding shopping lists?

Is it true that women do *more* housework than before the invention of laborsaving devices? And that men still do a negligible amount? Why don't art galleries display more images of modern woman's daily domestic grind? Isn't this worthy of painting?

Anyway, so much recent art is obscure and inaccessible—must this be so?

Is it possible to bridge the gap between high and popular art? Why is great art so often the size of a wall and not a postcard? Can art be visually appealing, humorous, *and* have a social message? Why, with so many female art students, do we *still* know of very few great women artists? And take the women behind the great male artists—what do we know of their lives?

Goodness me! I quite lost myself in this flood of thoughts and entirely forgot Art's shoes bubbling away on the stove.

Don't get me wrong. I believe that Art and his friends and predecessors have created truly great works and enriched our ways of seeing. But it's also important to present other possibilities.

Forty-two of these other possibilities have been produced by Sally Swain. But now, back to the housework.

Sincerely,

Housewife of Art

Housewife of Art

GREAT
HOUSEWIVES
OF ART

MRS. WOOD

hopes the toast won't burn

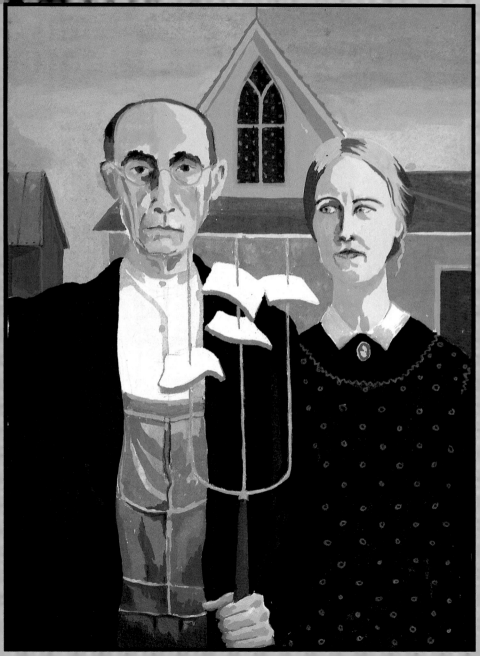

MRS. MANET

entertains in the garden

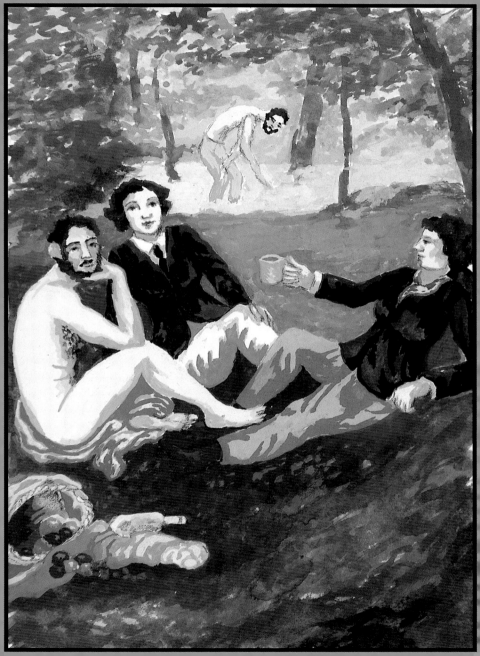

MRS. BACON
bakes a cake

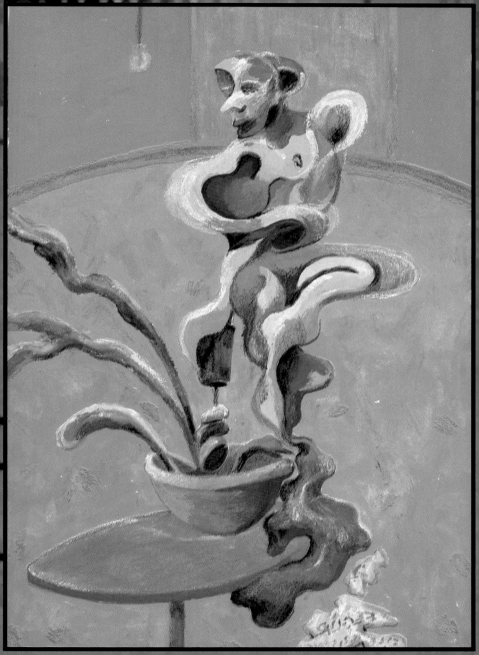

MRS. POLLOCK

*can't seem to find
anything anymore*

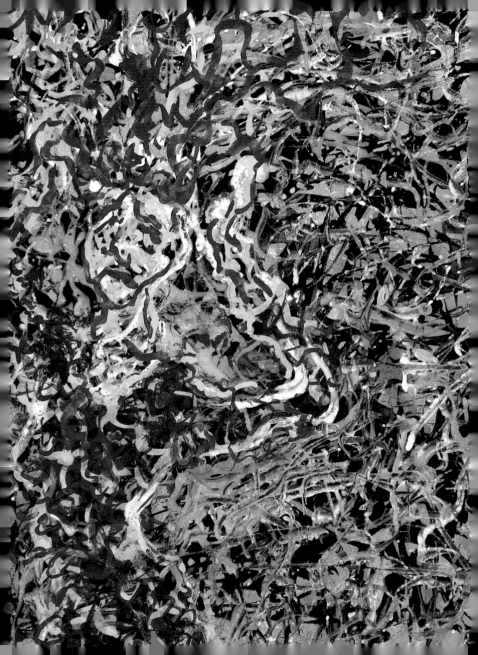

MRS. DEGAS

vacuums the floor

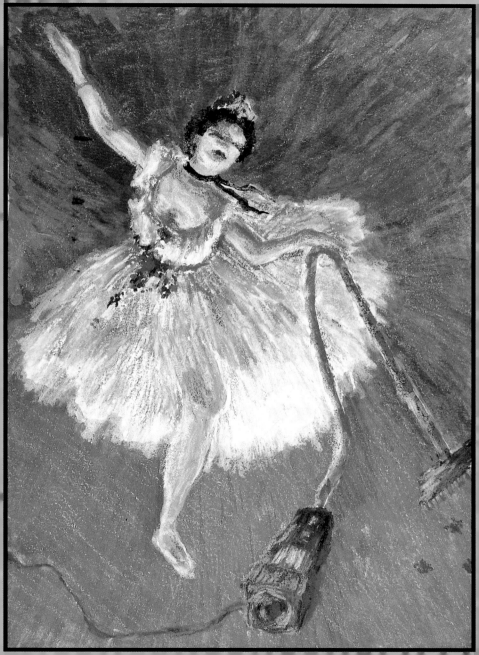

MRS. MAGRITTE

tidies the hat rack

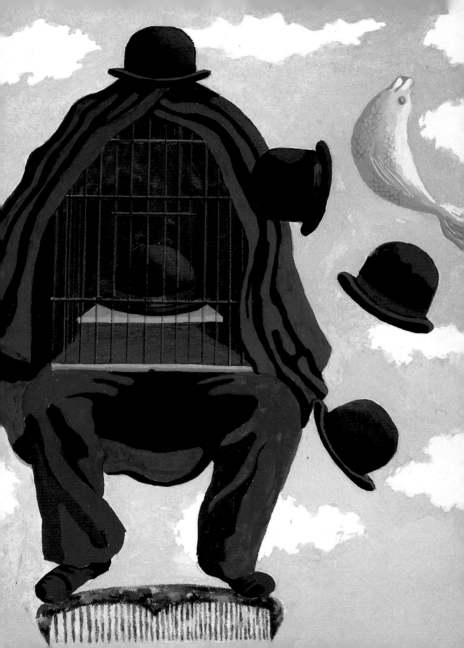

MRS. BEARDSLEY

won't go to that *butcher agai*

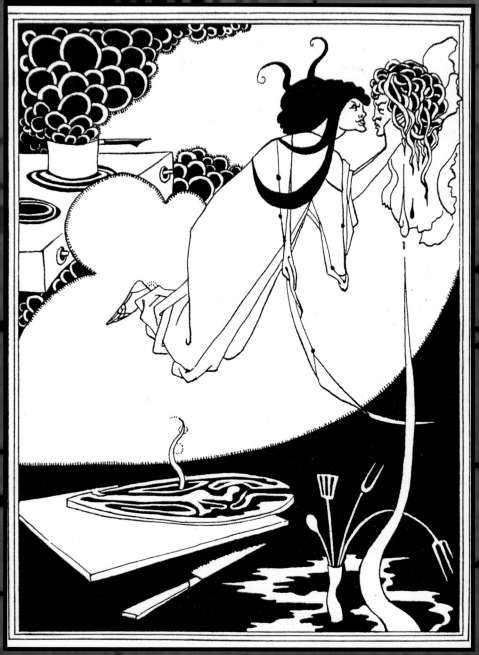

MRS. DALI

hangs out the washing

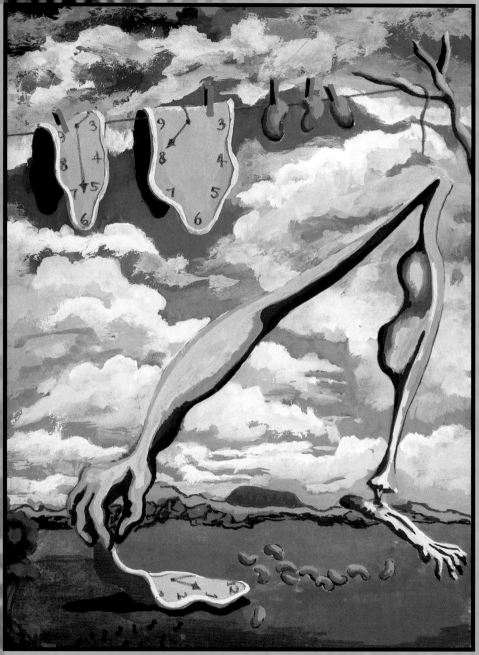

MRS. MALEVICH

bleaches the sheets

MRS. KANDINSKY

puts away the kids' toys

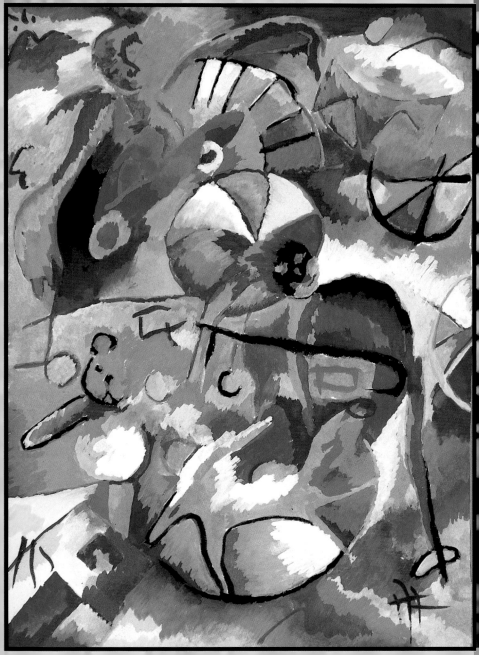

MRS. LICHTENSTEIN

sobs ...

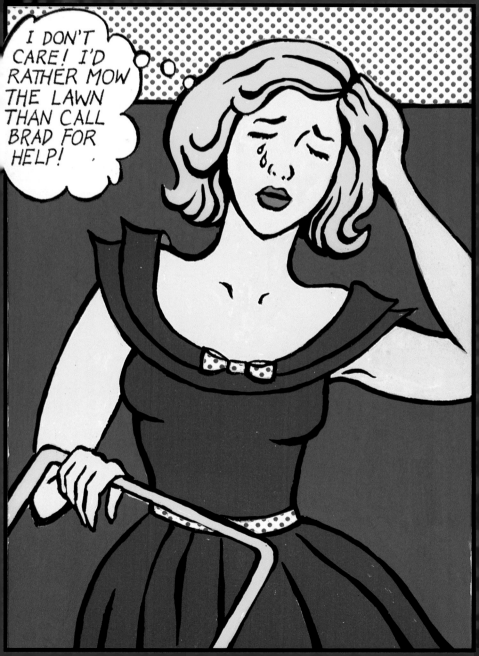

MRS. MONET

cleans the pool

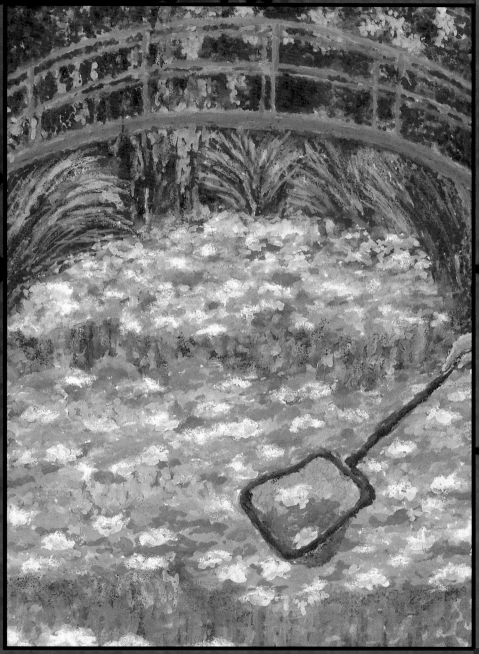

MRS. CHAGALL
feeds the baby

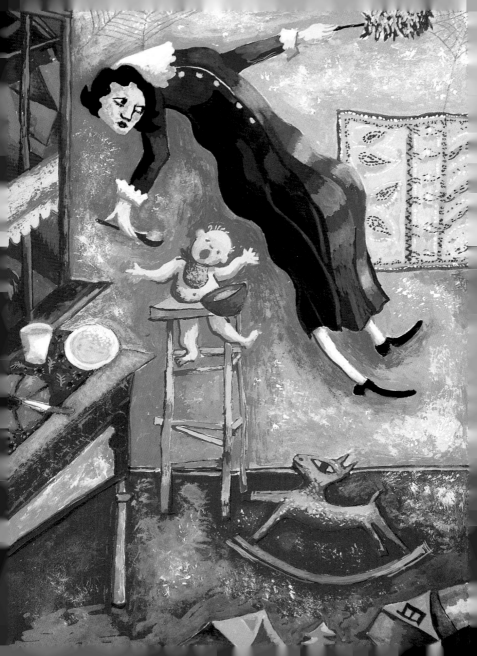

MRS. KIRCHNER

files her face every morning

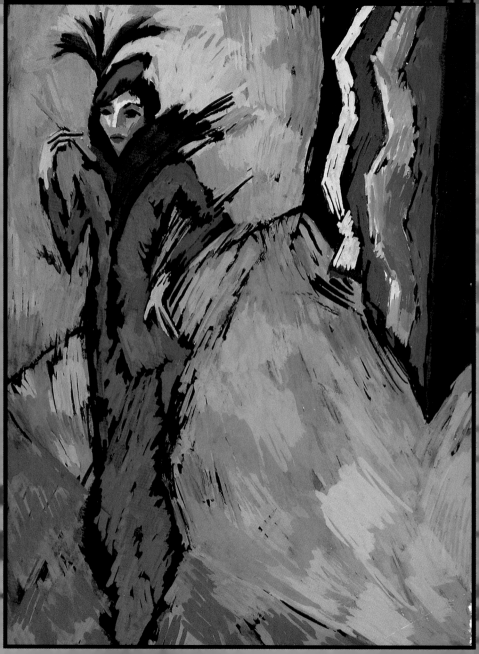

MRS. DUFY

runs a bath

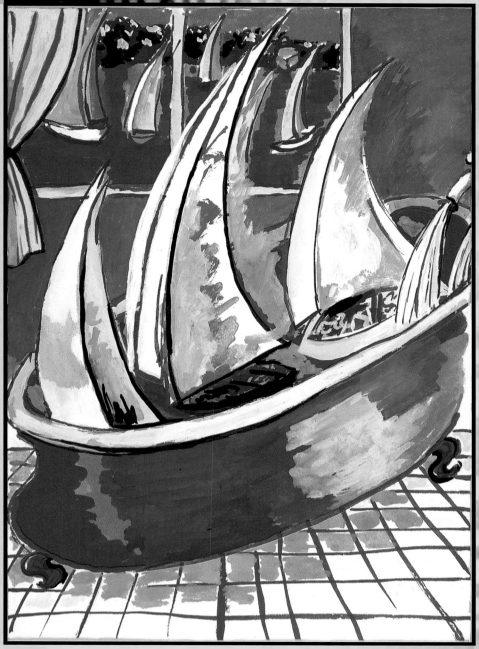

MRS. KLIMT

sews a patchwork quilt

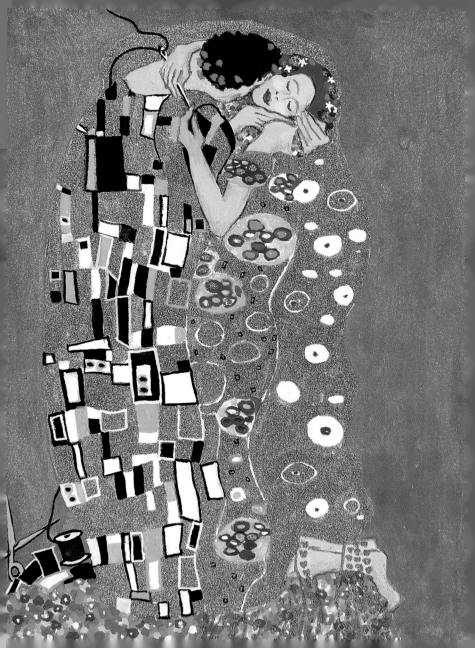

MRS. TOULOUSE-LAUTREC

cleans the toilet

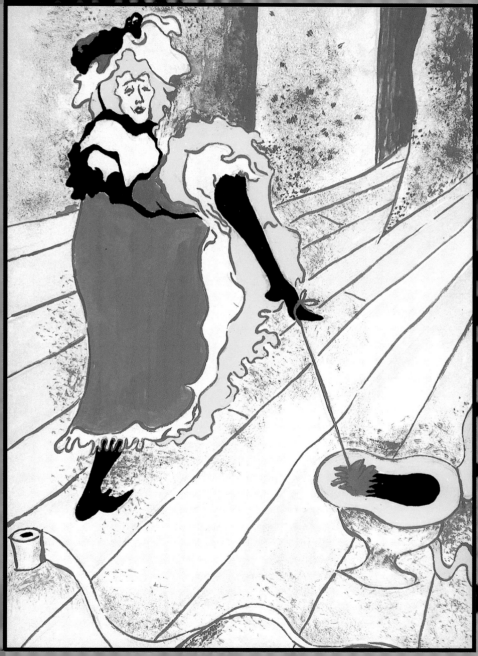

MRS. SEURAT

adjusts the TV set

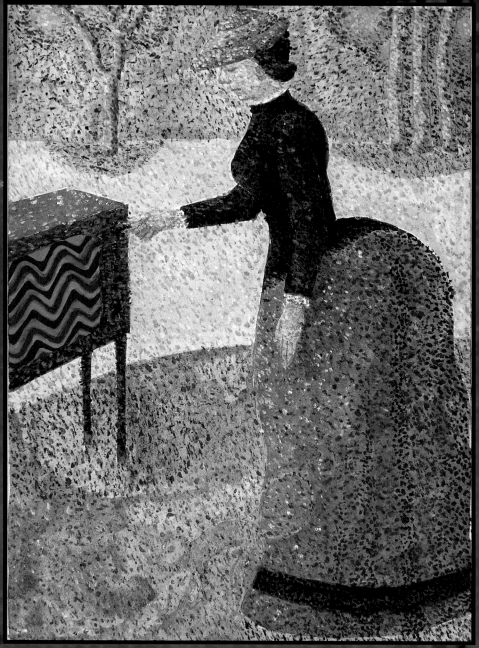

MRS. RENOIR

cleans the oven

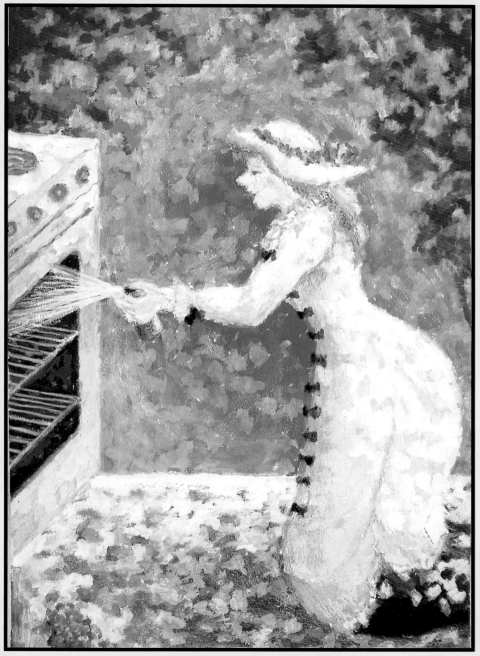

MRS. GAUGUIN

has a Tupperware party

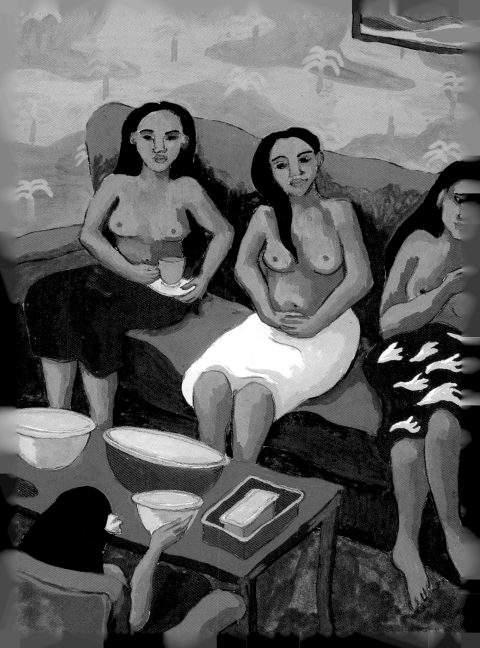

MRS. ROUAULT

washes the kitchen window

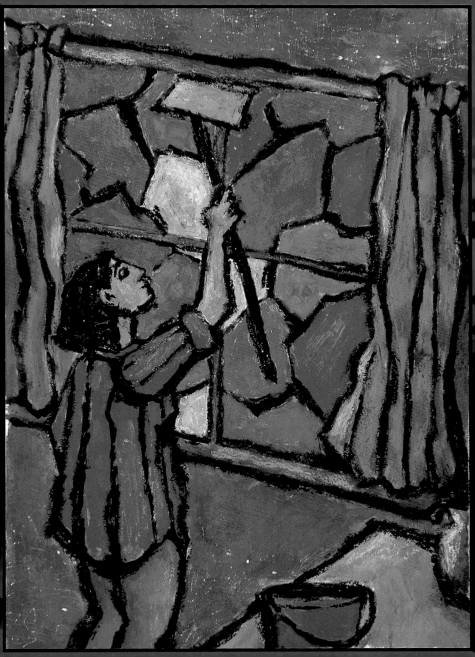

MRS. BRAQUE

sets the table for dinner,
while playing the violin

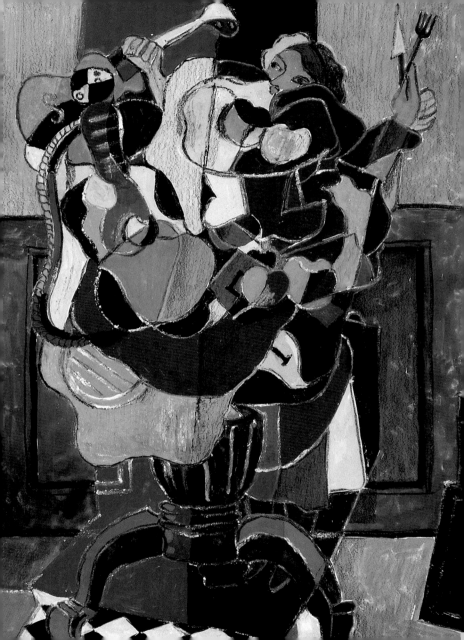

MRS. NOLAN

posts a letter

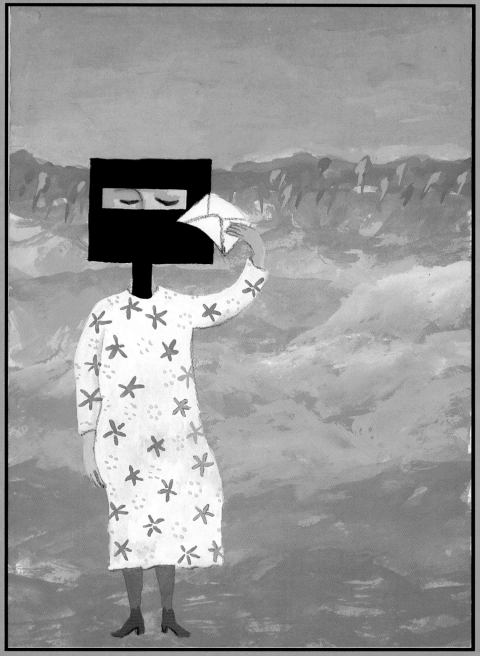

MRS. DAUMIER

takes out the garbage

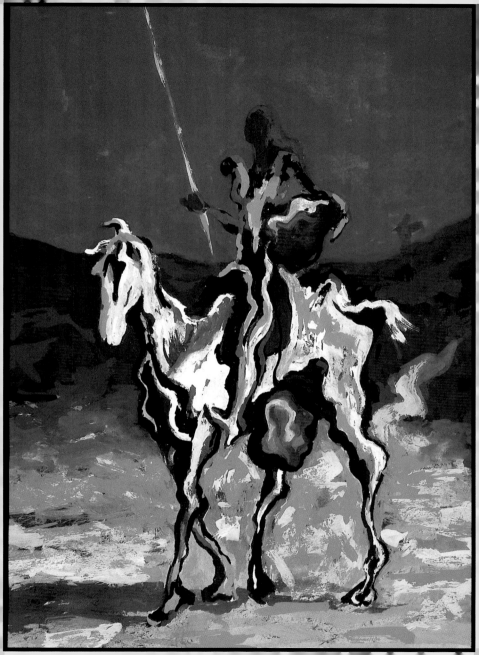

MRS. DE CHIRICO

feels agoraphobic

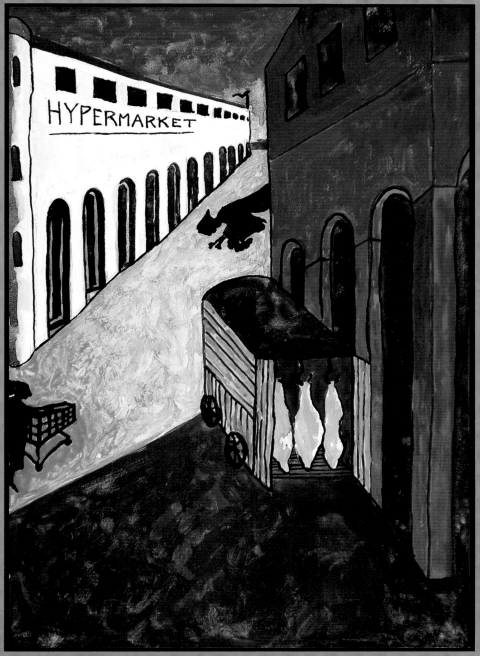

MRS. KLEE

cleans out the bird cage

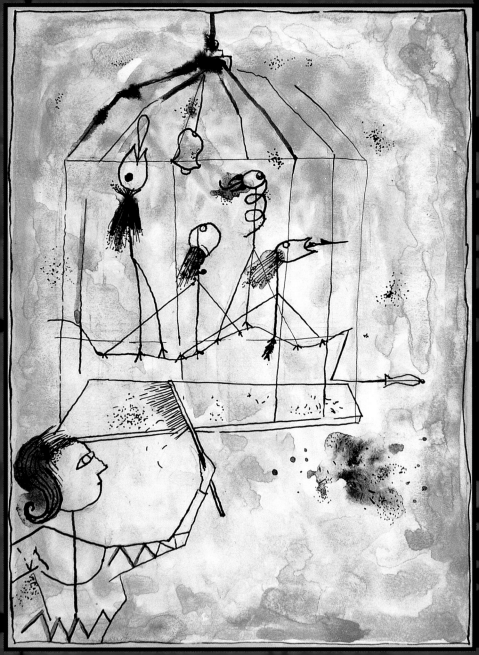

MRS. MODIGLIANI
relaxes after a long day

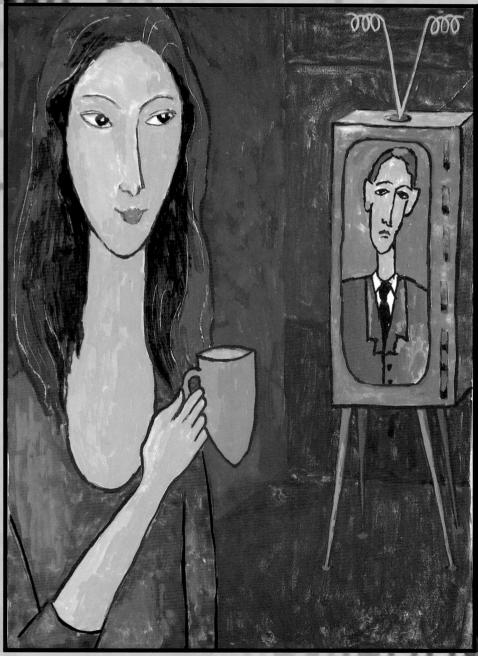

MRS. MUNCH

bemoans the tomato sauce

stains on the wall

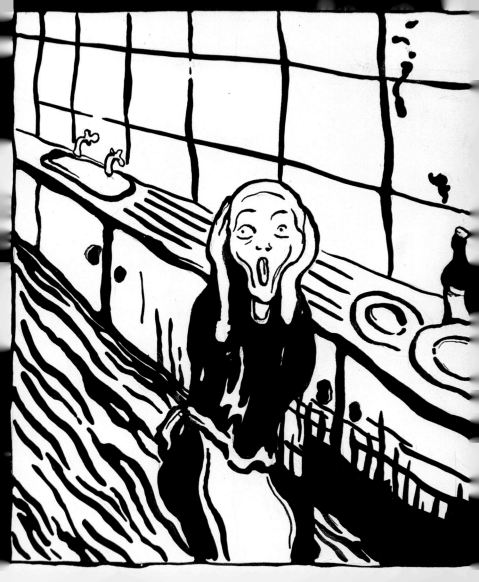

MRS. CALDER

dusts the furniture

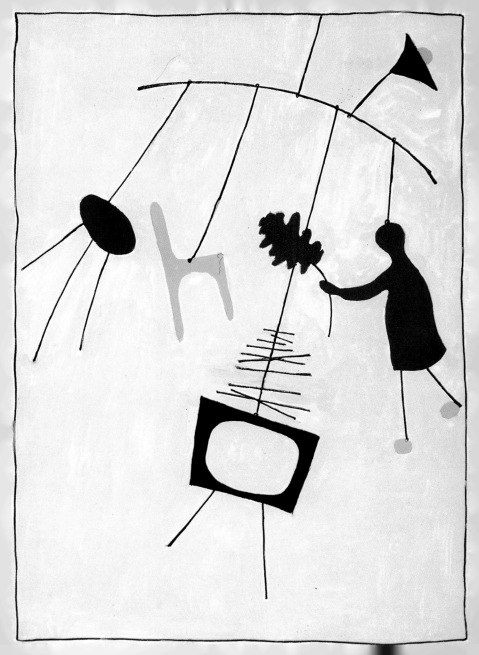

MRS. MONDRIAN

mops the floor

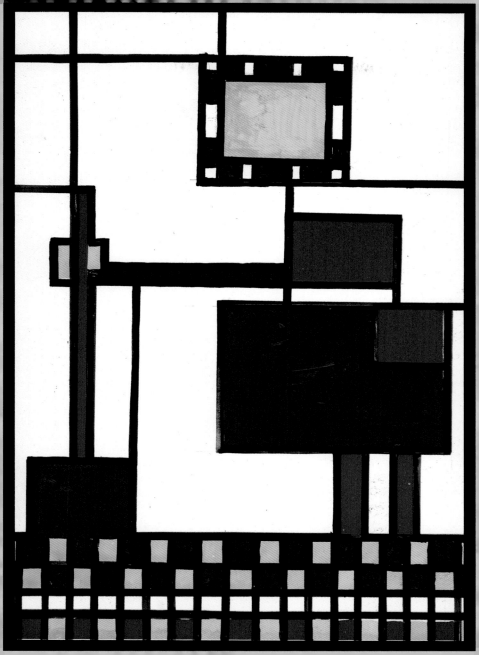

MRS. ARP

reads the paper (according to the laws of chance)

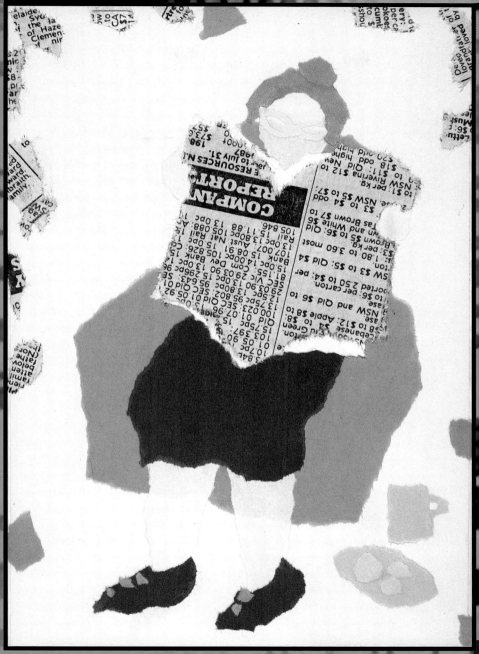

MRS. ROUSSEAU

feeds the pets

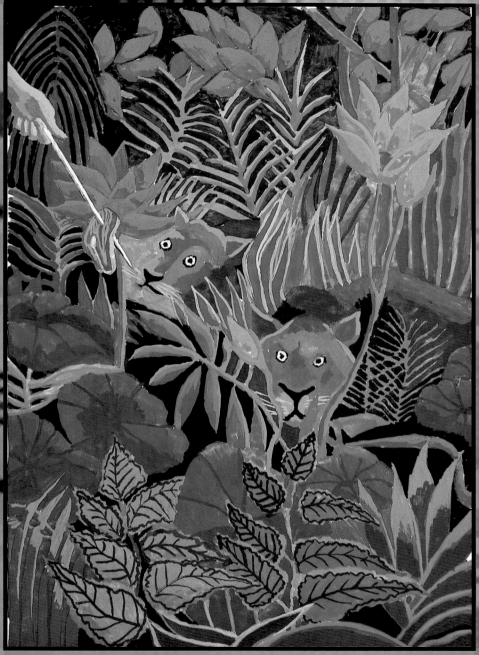

MRS. PICASSO

dusts the mantelpiece

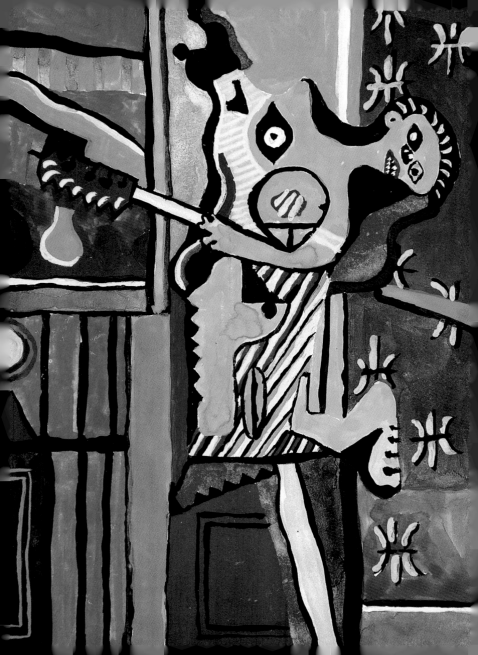

MRS. ROTHKO

scrubs the carpet

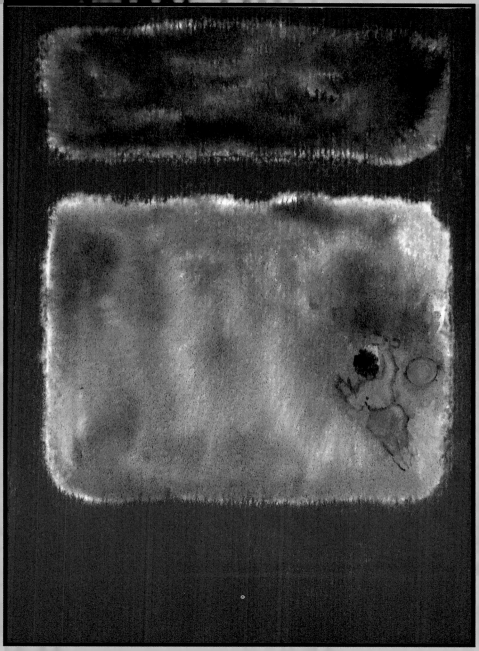

MRS. MATISSE

polishes the goldfish

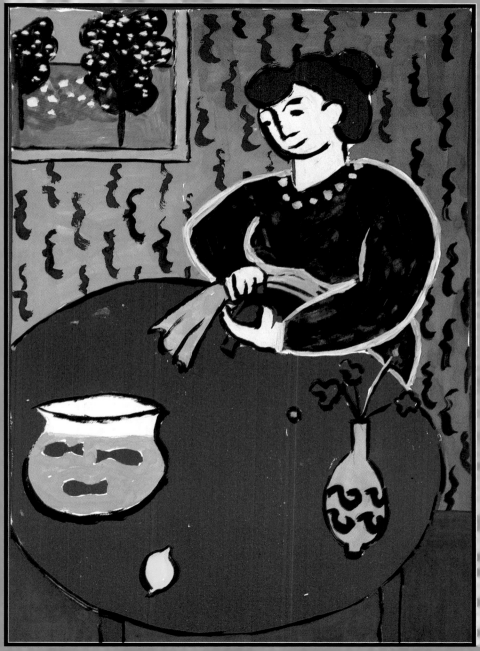

MRS. MIRÓ

sweeps the floor

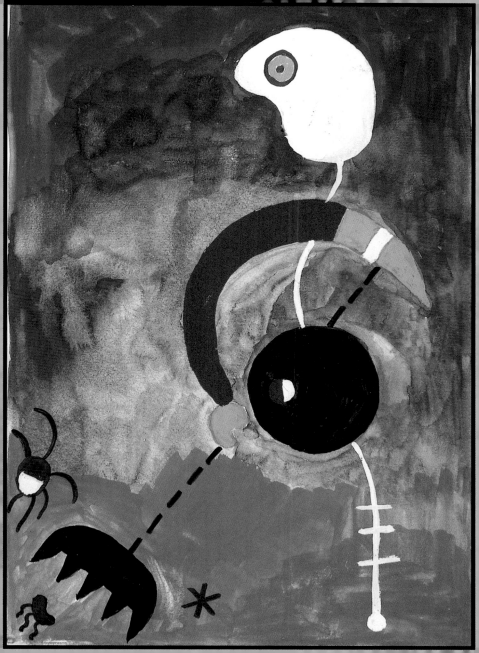

MRS. VAN GOGH

makes the bed

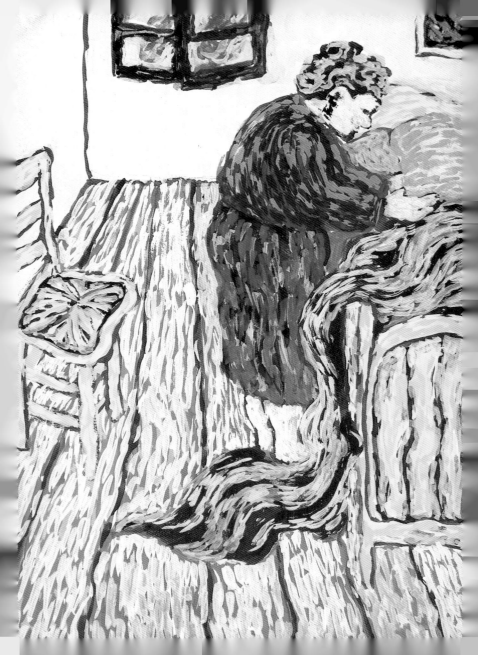

MRS. LÉGER
makes carrot juice

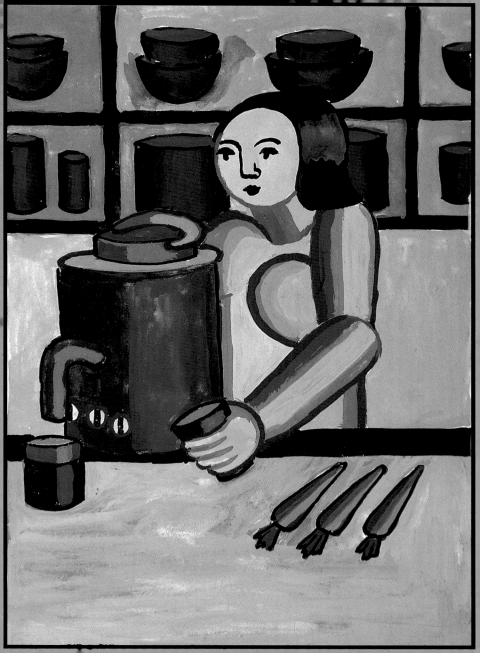

MRS. DUCHAMP

rids herself of those unsightly

facial hairs

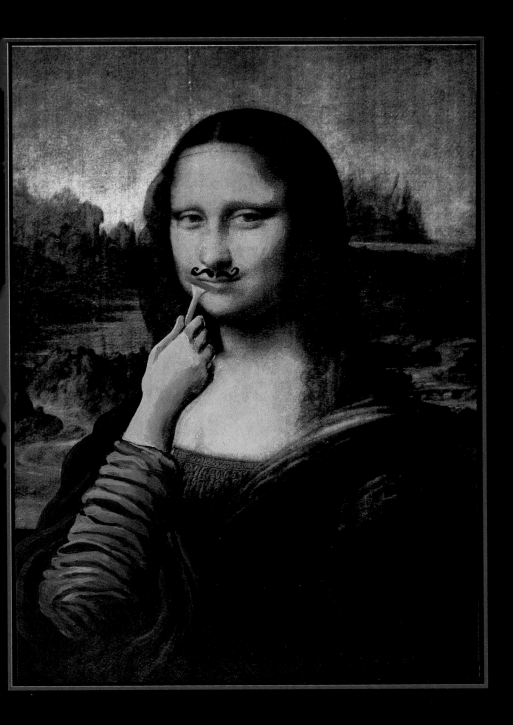

MRS. WARHOL

*is of two minds about what to
cook for dinner*

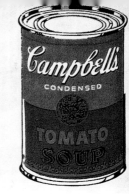

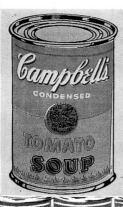
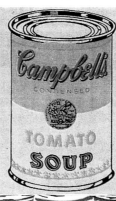
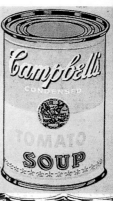

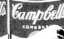
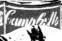
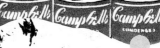

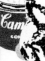
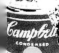

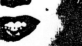
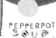

MRS. CÉZANNE

does the weekly shopping

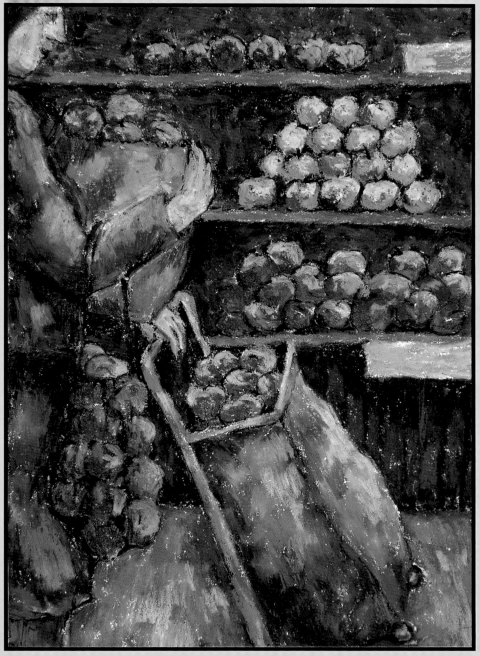

MRS. MOORE
has that empty feeling

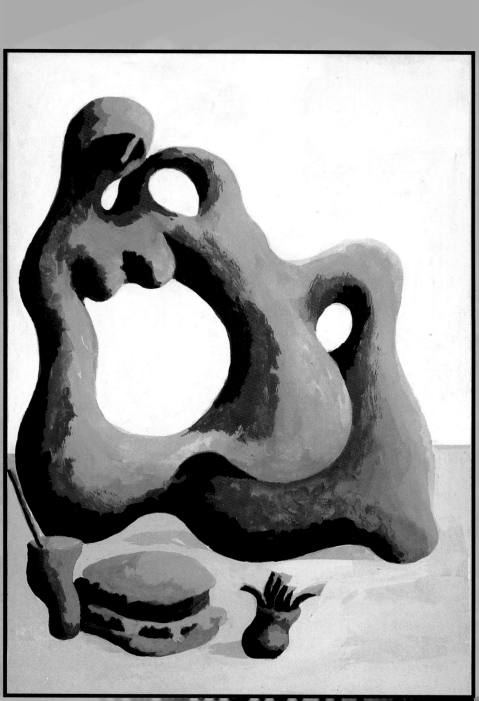